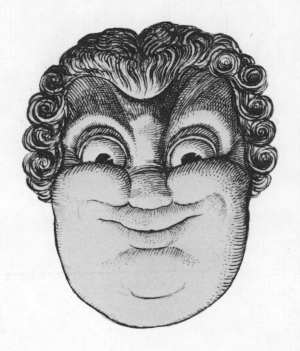

To Paul —
love Sophie
x

AHA

LAURENCE WHISTLER

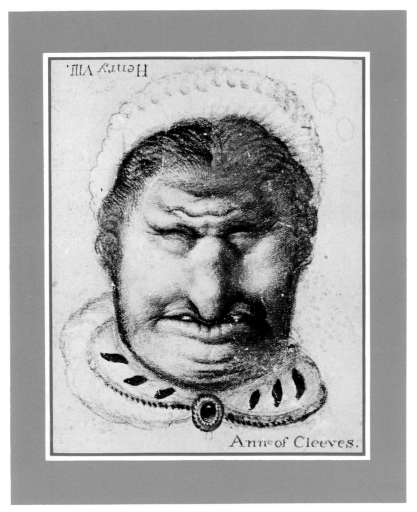

· MDCCCCLXXVIII ·

· J · M · MCMLXXVIII ·

BY REX WHISTLER AND

AHA

FOR KINDLY offering their reversible faces
for display, my thanks to
the Shell-Mex and B.P. Ltd Advertising Archive,
to Lord Norwich,
The Baroness Raben and Mrs Herbert Agar,
and, for providing photographs,
to Mr Derrick E. Witty.

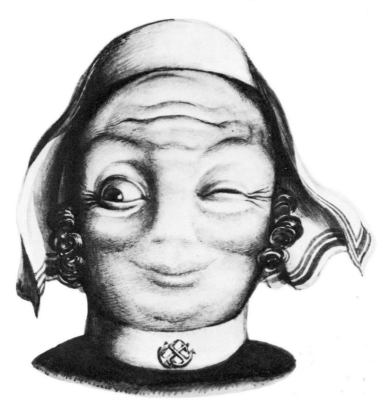

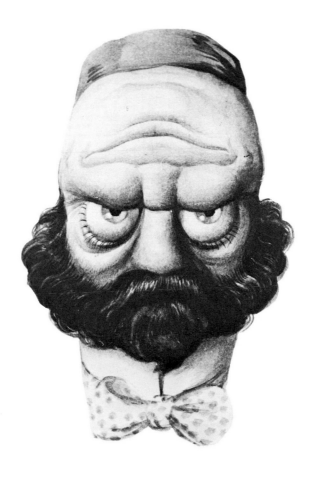

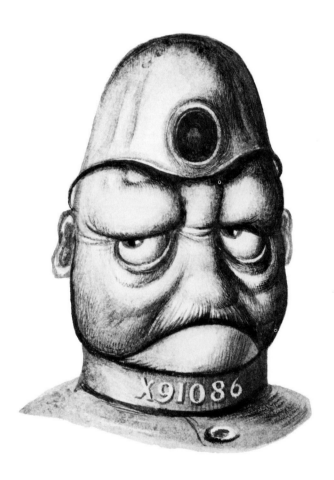

[*Introduction continued*] . . . by his friend, Edith Olivier, that Secker was publishing. In 1930 he payed such a visit, and Senhouse, alive by then to his sense of humour, showed him the book, and recorded on the flyleaf that Rex was 'delighted' by it. Chiefly he was delighted by the visual trick, but partly too by the mockery of a pompous and authoritarian figure: any such figure would have served, Queen Victoria, Napoleon, the Viceroy of India: there was no great animus against the Roman Church as far as he was concerned. No doubt he had seen weak examples of this kind of thing before: I believe he had attempted it himself in childhood. But this is what set him off, in 1930, happily developing a joke that is now peculiarly his own. How and where he immediately used it on characters of various kinds I explain BELOW.

A CHEERFUL NOTION OF HUMANITY—that on the whole is surely what Rex Whistler had, to judge from his gallery of characters that follows, though it cannot be denied, in fact it would be rather unobservant not to notice, that there is a hint of ambiguity in all his portraits here, enough to suggest that he detected and portrayed a certain two-faced quality in his sitters.

For him it all began in 1928 when Jack Beddington, the enterprising publicity manager of Shell Petrol, wrote to Professor Tonks asking if he could recommend a young artist who would be good at drawing witty advertisements; and Tonks at once recommended my brother, who had recently been his pupil at the Slade. So for a year or two Rex provided funny drawings for Shell, and later for B.P. Ethyl, in several series that will be remembered by those who are old enough, always illustrating words, sometimes very funny themselves, that were supplied ready-made to him . . . [*Continued at the end*]

Nothing succeeds like success, they say,
And you once again proved it on Derby Day.
What prompted you, Ernie, to pick an outsider
At fifty to one, and a novice astride her?

I can answer that!—London! It's right in your bones,
The damnable cheek of its bricks and its stones.
You're as smart as the cut of your whistle-an'-flute,
With a crease like a knife and a titter to suit.

Did you tell me your Dad got you started the night
All the Victory rockets went up in a flight?—
Or was it one Sunday at Kew that the blink
Of the dirty old river got into that wink?

Comes barging through the crush on Epsom Downs
A runt who's spent a lifetime with his frowns—
The very image of my own bad luck . . .
Displeased to meet you, Mr Habakkuk!

Yes, I'm afraid we've met before.
One evening, in the rush-hour jam,
I knocked your elbow and you swore.
That night I failed in my exam.

I stood beside you for a bit
Under an archway, one November,
Watching the rain. Remember it?
Well, I'd been sacked, so *I* remember.

It's funny—but whenever in a crowd
You shuffle past me, muttering aloud,
It's been a day when things have run amuck . . .
Sad to have met you, Mr Habakkuk!

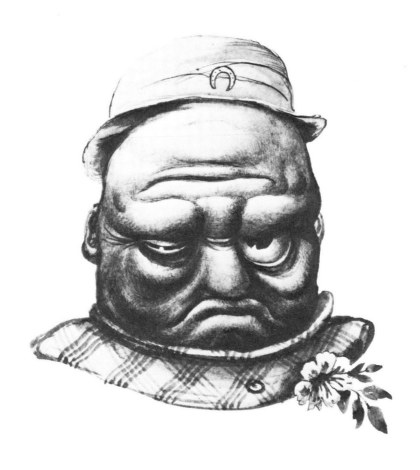

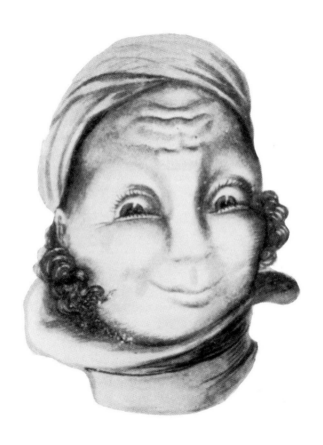

And setting in to rain of course
And never seem to spot a horse
And Father warning to go steady
And don't know where to find the ready
And dragging round the agents then
And Doris wanting to know when
And always visitors at home
And nothing at the Hippodrome
And nothing either day to do
And Saturday and Sunday too
And me and Doris here again
And setting in of course to rain

And Saturday and Sunday too
 And all the fun of say and do
And raindrops pimply on the walk
And bits of other people's talk
And little glances as they pass
And my reflection in the glass
And cakes with marzipan for tea
And in the music Bert and me
And stay there ledger on the shelf
And typewriter go rust yourself
And arm in arm and true as true
And Saturday and Sunday too

Up in the sun's blue ballroom he will linger,
And while he talks to cities like a friend
He'll balance his horizon on one finger
Or roll it idly over, end to end.

The radio failed him first. Now daylight fails.
In the fog's carpet—all too little worn—
Somewhere between the Norfolk coast and Wales
One factory chimney pricks him like a thorn.

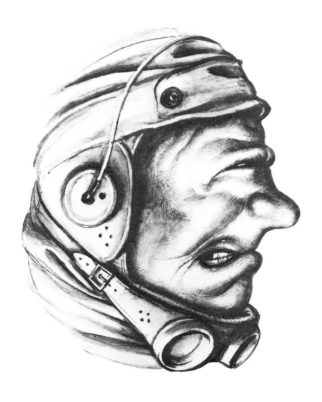

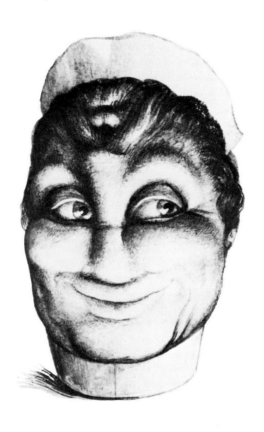

You see, I have not yet thought fit
To tell the Doctor who I am!
(To you, I'll whisper it!)
Once I . . . O you may sit,
All of you, pray be seated—you, Sir, too,
Keeping so rigid on the darkened shelf,
Our wish is, you relax yourself.
Perceive!
An Emperor does not grieve.
Franz Joseph is Franz Joseph to the end!
And not one left, one loyal friend . . .

Nurse?
Quite the reverse!

My patient wakes up glum and surly,
But I *adore* the early-pearly,
—I always have!

I'm just a girl who hates the city
And thinks the country sweetly pretty,
—I always was!

I say, for ailments largely neural,
There's nothing like the truly rural,
—I always shall!

And if I find the patient tearful
I make him comfy, bright and cheerful,
—I always can!

So when it's time to wash the lazy
It's best to order: 'Upsydaisy!'
—I always do!

The finished article—how noble!
Flower of a Mind—nay, rather, fruit—
In concentration, how acute!
And in circumference, how global!
Think what experience it contains,
What dreams, what schemes it has revolved . . .
Ten thousand crosswords partly solved,
A lifetime in suburban trains . . .
What's more, with life again to plan,
It wouldn't alter one iota.
'Fun?' it says, 'I've had my quota!'—
What a piece of work is man!

Item: manchild, not quite new,
 Biting more than it can chew;
Every day in wilder squall
Reinterpreting the Fall;
Every year a richer medley
Of the incipient Seven Deadly.
Even so, that hungry face
Hungers even now for Grace,
Beckons and rejects its food—
Cross it! Cancel out the mood!
Bring it bawling to the font,
One stone seven of I WANT!

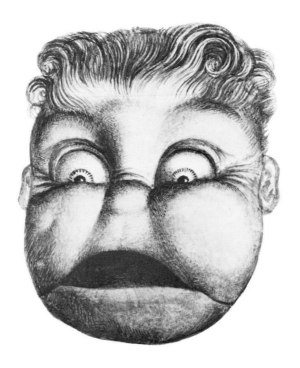

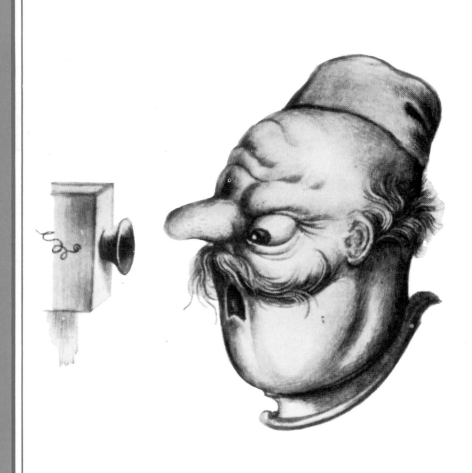

A fire in the Manor of Speaking!
 Well, ain't that a stroke of good luck—
Just tonight—when we've mended the hose that was leaking
 And done up the truck!
And to think off and on we've been grumbling
How folk don't have fires like they had—
Why, wasn't it only last night you was mumbling
 How business was bad?

Their din will amaze the night air
And frighten five villages there,
As they whirl in a wink
From Tremble to Think,
As they rocket through Fare, Ware and Tare.

Then at last, in the darkness ahead,
 The encouraging red.

Old fellow, so devilish daunted,
 With your just-seen-the-headless-man look,
Is your much-restored mansion then haunted?
Can it be you've encountered the spook?

'O it's haunted, it's haunted, that's certain,
By an Urge, an unspeakable Thing,
That licked up the lace of a curtain
And gnawed through the library wing,

'Until now it's quite close to me listening
To all my wild talk, through the door.—
Look, its eye at the keyhole is glistening!
See its breath rolling dark down the floor!'

Listening to a voice that lingers—
Curious story—charming lilt—
Shoulders ease themselves, and fingers
Push aside the encrusted hilt.

Fingers laced on midriff settle . . .
Eyelids flutter, eyebrows twitch,
Mouth turns down, incisors rattle,
Heavy breathing sets the pitch . . .

Yet be sure at crack of day
Ardent eyes will fix the teller:
'Splendid story,' he will say.
'Got what he deserved, that fellah.'

It is the thousand-and-oneth night.
Scheherazade is through, all right.

She looks demure,
 So plump, so sure,
On cushion sitting,
No fear admitting,
And weaves the tale that winds about
And must (whatever else) last out.

Bright stars creep by
Dark minaret.
Pale turban-jewel
Dare not set.
'And so,' she says, 'And next'—'And when'—
'And soon'—'And now'—'And then . . .' 'And then . . .'

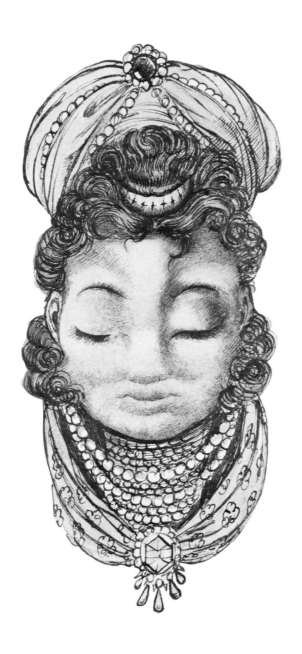

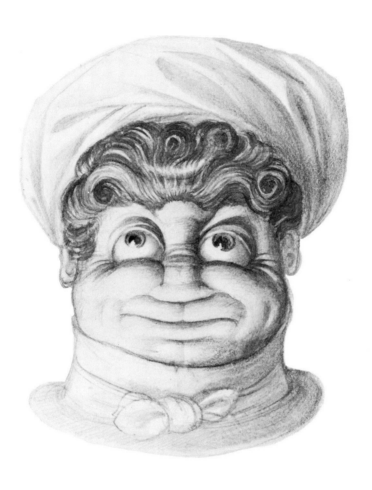

Bun, Bun,
What's up, old son?

The scent of your bread
Could restore the dead,
Poignant as rain
In a sweltering lane—
As new-mown hay
Just a hedge away—
As new-laid tar
To a passing car—
As a bonfire whirling
Blue hair uncurling.

Can a croissant brook
So extreme a look?
Can a milk loaf bear
Such a baleful stare?
Can a batch support
Such ferocious thought?
Did the last small brown
Invite that frown?

Mrs Bun the Baker's Wife
Appears distinctly pleased with life.
Why? *The Pastrycook and Baker*
Contains the very news to make her
Daydream at the counter, humming.
It mentions in small print the coming
Marriage of Miss Saffron Bun
To Master Dose the Doctor's Son.

I'm not a snob of any kind. I always make a rule,
When well-to-do or titled folk come down to see the school,
To leave a new prospectus for perusal on the sofa
And saunter out to have a word discreetly with the chauffeur.
'Been down to Glyndebourne yet?' I say. 'Her ladyship like ballet?—
Taking you abroad this year?—Oh, Champéry! A châlet?'
It indicates a subject when I potter in once more.
Remarkable how they forget they came here to explore!
And if a photograph will do—why show the upper floor?
The dormitories, I feel, look old. (My wing, of course, is modern.)
And, viewed through iron bars, the garden *does* look somehow . . . sodden.

Well, say I get the little pet—how wholesome he should find
That boys of every class, to me, look much alike behind!
Yes, it's cheering while adhering to the spirit of democracy
To feel I've reached the bottom of the British aristocracy!

I wouldn't swap my job with yours, and muck about with trays.
—A chauffeur gets a laugh from what he meets with, anyways!
—We just come back from tryin' to find young Anthony a school,
But as it turned, they didn't like the look of the old fool.
I had a word with him meself. That's straight! *He's* nothin' much!
He comes up quiet-like while I was workin' on the clutch,
Says one thing and another, very matey, very decent.
Well, I read about these 'prep schools' in the *Graphic* only recent,
How they bash 'em till they holler. Well, I saw he'd take some chaff,
So I bet you whacks 'em *horrible!* I says—I had to laugh—
'I'd like to see you try,' I says, 'to whack *my* lower half!'
Says, 'Don't you be impertinent!'—'Impertinent!' says I,
'Impertinent, sez-you-n?' I says. 'Just like to see you try!'

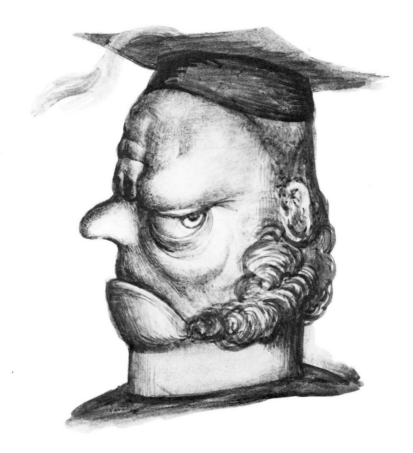

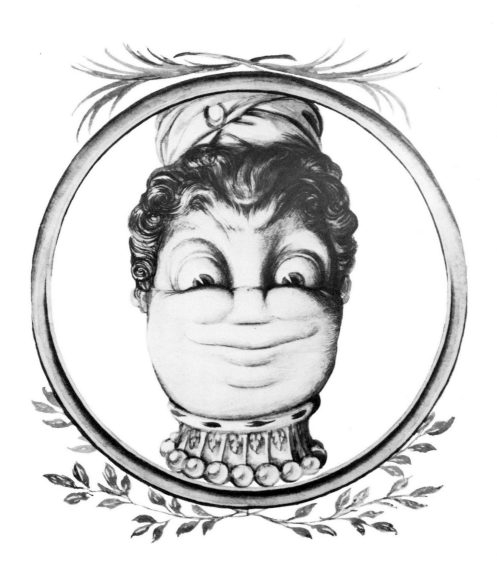

I ord Littleray of Sunshine won't
Enjoy your talking slang. So don't.
Don't thank him for a nice 'week-end',
Write 'Saturday to Monday', friend!
Say 'luncheon'—never 'lunch'. Agree?—
Echo his words! To him, you see,
The Reds are still damned Radicals,
And all our modern dances Balls.

T he Lady Cardigan FitzBaddeley
Believes in Feminism madly,
In Sitting on Committees gladly,
And even Socialism—sadly,
And even Men—a little sadly,
But Antivivisection—gladly!
While Maharishis beckon madly
To Lady Cardigan FitzBaddeley!

Young man, young man, in spite
Of that clear brow and chin,
And O those bright, so bright
Round eyes above that grin,
And though it's now so easy
To gallivant till dawn,
With swimming before breakfast
And cartwheels down the lawn—
In spite of all your vigour,
The roundings of your face
Cut quite another figure
When we take care to trace
What even now is in them:
A face—but none so new—
Bald, chap-dropped, weedy, solemn,
That must, one day, be you—
Is it not true?

Old man, old man, you know
For all your polished crown
And tumble of beard below
And never unfastened frown,
For all that's held of caution
In pouches under eyes,
Dealers and double dealers
That made you doubly wise—

Somewhere in you lives on,
Somewhere in you lies hidden
A madcap hot young man
Who likes joy best forbidden,
Who likes a risk, who'd even
Like once again to know
The strict astringent bugle
That soured him long ago—
Is it not so?

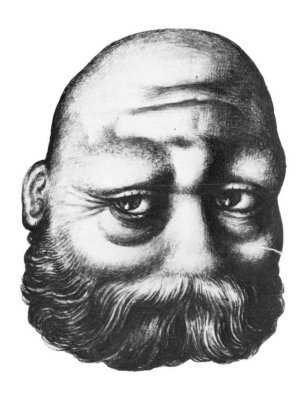

Elementary, my dear Watson,
As Holmes never actually said,
Though conscious that the elementary
Seldom penetrated Watson's head.
If asked to name something in common
Between Robin Hood and the 'tec,
Watson would have hazarded. . . . probity—
Independence—risking one's neck.

This page gives a stranger answer.
Though in looks they differed a lot,
They shared, by some curious economy,
Exactly the same physiognomy.
Believe that, Watson, or not.

The popular notion of Robin Hood
Is, and was, of a man philanthropically good:
Not one whose method was, frankly, to mug . . .
What the Sheriff of Nottingham saw was a thug.

Into his malmsey he'd mumble a bit.
'A fat lot of use is the king's writ.
You'd think we were living in primitive times
When seven little kingdoms competed for crimes,
And the kings all began with "Æ". You know—
Ægnog, Ægwysc—they came in a row.

'Dogs like Hood should be locked in cages . . .
Isn't this supposed to be the Middle Ages?

'No wonder responsible people get het up
About the entire medieval set-up!'

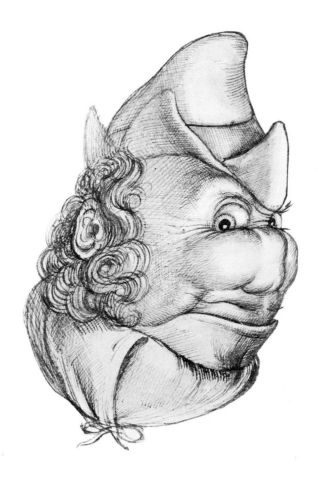

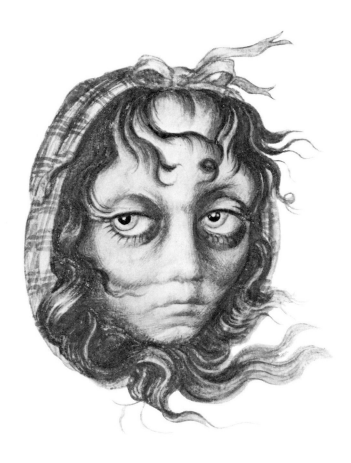

Be home by twelve!
 The one condition
For beauty tremulous
 With ambition.

Fairy Godmother,
 You did tell her—
Did speak plain
 To Cinderella.

And she forgot
 In the Prince's arms,
Forgot in the whirl of the waltz
 Those terms.

Silks to rags,
 And rags to dust—
Quick as whirring cogs she must
 Be home by twelve.

The sisters truly thought she looked like that,
 Cinderella, with her brush and pan,
Slip-slopping down-at-heel around the flat,
 Ash-coloured where she sat,
Deep in some fatuous daydream of a Man.

Great cow eyes, all the bigger ringed in dirt,
Hair never tackled, hands begloved in grime,
Poutingly patient in a cast-off skirt—
 So *good* it almost hurt—
So meekly willing to work overtime.

There's moral beauty here. We only need
A fairy's wand, which means a taken chance,
To make the unnoticed gifts we were decreed
 Beyond belief succeed,
And win the Prince, or Princess, in life's dance.

Taximan, taximan, parking your cab,
The hut's full of laughter, but tea's on the slab,
And I think if you're quick there's a bun you can nab.

Taximan, taximan, memories burn.
Better to think of what's present, you'll learn:
The chip in the saucer, the shine on the urn.

Taximan, taximan, pull away soon.
There's a couple must get to St Pancras by noon,
Or you'll start them off bad on their first honeymoon!

Taximan, taximan, drive back to bed.
Of course we're all sorry the old woman's dead,
But you've not long to wait, as the old woman said.

Easter Sunday! Easter Monday!
Crowding in the vintage car!
Get the shiny weather one day!
Oxford? Done it! Rye? Too far!
South Downs? Windy! Try the Weald!
Not where all the others are!

Behold him, plural in the field.

Stop! We couldn't ask a better!
Here's some flowers no one found!
Here's a tree without a letter!
Here's your eats, lad, on the ground!
Dad, strike up the old cigar!
Tune us in to something, Ma!

Overflowing with the sound.

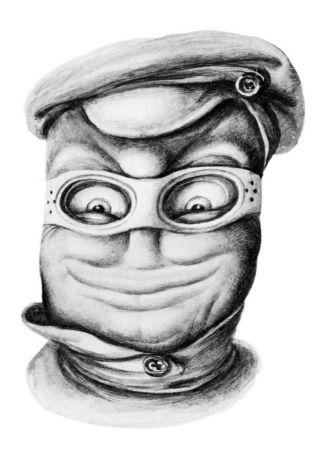

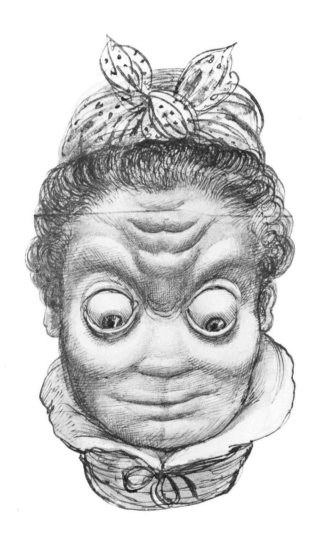

Children whisper what you are in dread.
Never seen you sitting on the bed,
Sitting upright hours on the bed.

Mumble mumble voices down below.
Clock's begun to swing them to and fro,
Swing the bedroom softly to and fro.

How much longer can you keep it tightened,
Keep it bursting from your fingers tightened?
Mrs Stringle, why are you so frightened?

He did seem, as we talked, a trifle silent:
Thoughtful, perhaps. Of course I'd heard the gossip—
Nobody's seen her for ten years—he keeps her
Locked in a room—and so forth. I'd forgotten.
We had farm-matters to discuss . . .

Then he was silent just a shade too long.
I glanced up, noticed that his head was tipped
Backward. Trying to remember something? Well, maybe.
Then in a flash I got it: he was *listening* . . .
No, not a sound! The building was death-still
To *my* ears. Just the clock's flat tick. And then—
You'll say I'm fanciful—it seemed as if
He wasn't there: had somehow joined the thing
Up through the ceiling: become one with it:
Was talking to it, all else drained away
Out of his sagging features.
 At this point
It seemed politer to withdraw!

Dear Commodore, *must* you so mind it
That all your ideas are used up?
If you knew how delicious I find it
To feel I'm 'an ignorant pup'!

Shall we talk about Kipling then? Clearly
Dylan Thomas is not up your street!
But I mustn't be priggish—you're really
Quite kind and pathetic and sweet,

With enchantingly out-of-date notions!
Still, today, we have learnt to expound
And even *control* our emotions.—
With you, it's the other way round!

Pansy Midshipmen are not
 Encouraged in the Senior Service.
D'you think Picasso and that rot
Would cut much ice with Blake or Jervis?

No doubt you'd like to tell me with
That grin, I'm just a poor old buffer.
Gad, Sir, I knew my Meredith
Before your Nanny called you duffer!

Your damned opinions may be smart,
Of right ideas you've none whatever.
When Einstein's bronzes are good art
The time will come to call you clever!

Till then, young man, it's apposite
To say you're just the opposite!

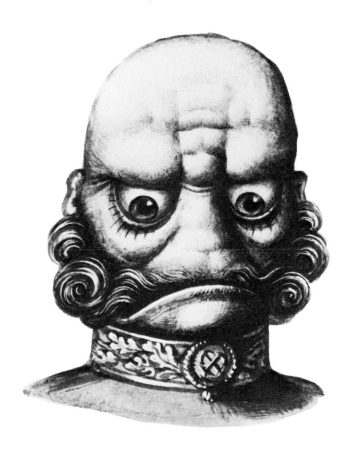

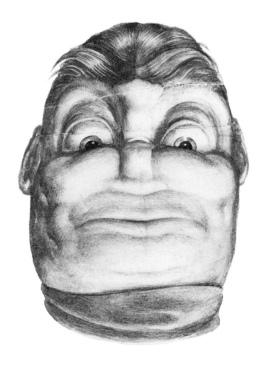

N ow don't go off with some idea
We scholars underrate physique.
I grant you, as you raise your beer,
Those biceps never taught you Greek.
What then? We're coefficient. We're
Complementary, so to speak.—
How shall I put it? We appear
Reciprocally strong and weak;
And, by corollary, it's clear,
Ought one another's aid to seek.
In fine—life needed you and me
To integrate one entity!

A bloke can use 'is fists a bit,
　But meet a brainy chap like you—
Christmas, 'e sees there's more to it
Than what the Noble Art can do!
If 'alf the clever things you said,
Just leanin' up against this bar,
Got fastened in my block today
An' got me seein' things your way
(*You*'ll call it, 'seein' 'ow they *are*')
I'd finish, standin' on my 'ead,
Where bleedin' angels fear to tread!

I certainly never would care to be
 The Mayor of Standon Ceremony;
To sit all day in the Mayor's huge parlour
Crossly arranging a week of gala.
All over that building they're spending their leisure
Thinking out ways of controlling your pleasure.
Yet if anyone dies on the Council they're at you
To give them the money to put up a statue.
And now that the little old orchards all harden
Into one splendid Municipal Garden,
With iron instructions and concrete edges
And iron and concrete seats in the hedges,
There isn't a lane with an honest puddle,
There isn't one lilac bush for a cuddle,
There isn't a solitary apple- or plum-tree
From here to the suburbs of Upper Gumtree!

I'd like to change places for one short season
With Madam the Mayor of Stanster Reason,
And walk in procession—the big drum thumping,
The cymbals twinkling and the trombones pumping,
The folk in the doorways bowing and clapping,
The flag of St George on the battlement flapping,
The church bells throwing a gay carillon—
To open a small white cricket pavilion.

And I'd like to be her on the Flower Show morning
On a bit of red carpet beneath a blue awning,
Brightly preparing to hand out the prizes
For blossoms of almost preposterous sizes.
But first to go everywhere dipping my cranium
Deep in the cushions of rose and geranium,
And hear now and then through the long afternooning
The band by the sycamore, simpering, swooning ...
How nice after such a big day to say, 'Our show,
Was truly, I think, a most *admirable* Flower Show!'

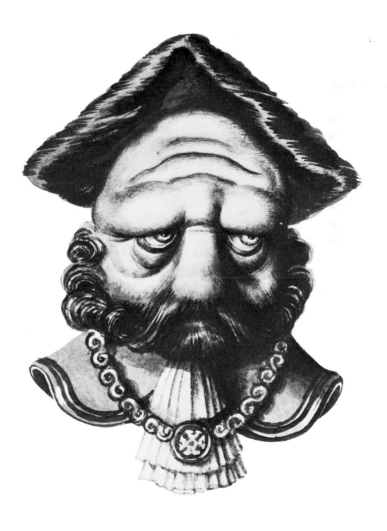

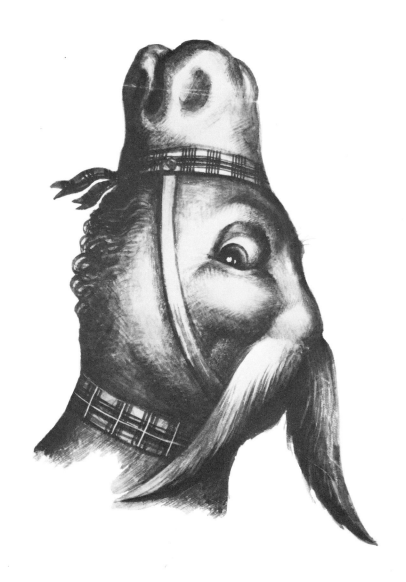

O saw ye bonnie Neddy?
For he's turned topsy-turvy.
He's changed into a Scottish laird,
A trick that's a'most scurvy.

Return again, good Neddy
Return and be a donkey!
That we may gas we hae an ass
There's nane that is sae wonky.

A braggart struts i' tartan trews,
A cap, or what ye ca' that.
But turn him up the ither way,
The man's a moke for a' that.

For a' that, and a' that,
It's certain sooth for a' that.
Moustaches smart can break a heart,
And mean a moke for a' that.

[*Introduction continued*] . . . Then in 1930 he himself suggested the series that is best remembered—one that was self-explanatory if also teasing, and needed, for the purpose of an advertisement in the papers, little in the way of caption. This series contained most of the drawings reproduced in the present book. In 1947 I wrote a set of verses to go with these types from the world of the 'Twenties—Old World as it was already becoming—and they were published under the title ¡OHO! by the Bodley Head. Now, eight other faces not drawn for Shell, but later in the 1930s for the children of friends, have been included. What put the whole idea into his head I have explained BELOW.

A SOUR VIEW OF MANKIND—this, clearly, in the main, is what Rex Whistler took, if his row of likenesses here following is anything to go by: not but what, if we examine them thoughtfully and turn them over with attention, we may arrive at an opposite conclusion; for the fact is that he seems to have been in two minds about the character that can be read from the same human features, or at any rate from the one oval of a human head.

For him it all began in 1682, though he was born in 1905: in 1682 a certain Peter Berault published a book called *The Church of Rome Evidently Proved Heretick*, and for a frontispiece provided a drawing of the Pope, very smooth and smiling, which, when turned the other way up, proved His Holiness to be entirely repellant and (evidently) heretick. Naturally this fold-out is nearly always missing from copies of the book—itself quite a rarity—but there was one copy that still retained it, and this copy belonged to Roger Senhouse, a partner in the firm of Secker; which firm was often visited by my brother because he was illustrating books . . . [*Turn to the end*]

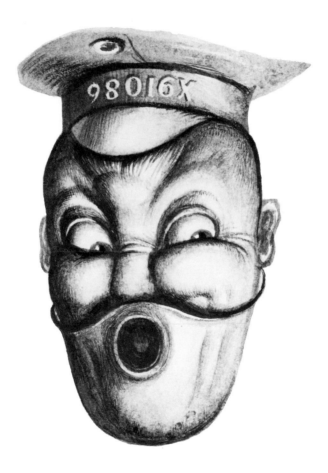

FOR SHELL

who commissioned many of these portraits.
They advertised
by making others laugh

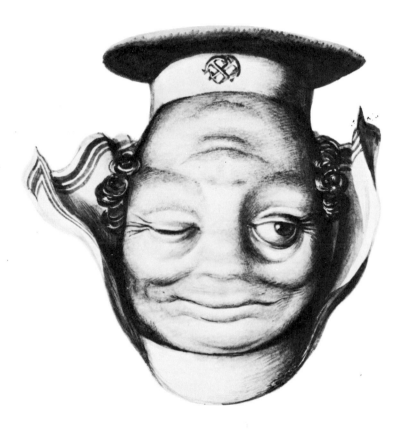

likenesses were made
for whom many of these
Creators of laughter in advertisement

TO SHELL

I THANK Mrs Herbert Agar,
the Baroness Raben, Lord Norwich, and
the Shell-Mex and B.P. Ltd Advertising Archive
for kindly allowing their reversible faces
to be displayed; also, for photography,
Mr Derrick E. Witty

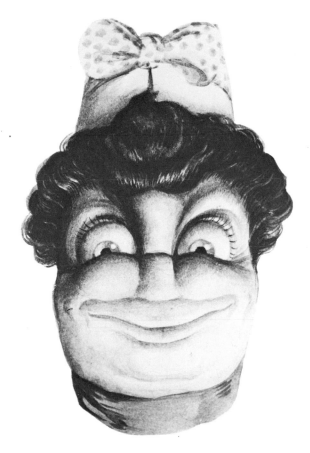

THIS EDITION 1978

© Text and pictures, Laurence Whistler 1946 and 1978

Bound in Great Britain by
Richard Clay & Co Ltd, Bungay

0 7195 3574 3

AHA

LAURENCE WHISTLER

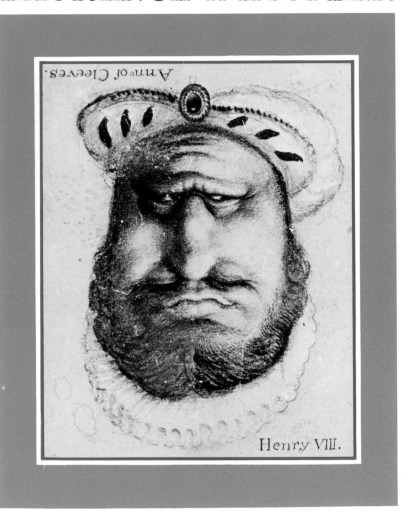

· J · M · MCMLXXVIII ·

· MDCCCCLXXVIIII ·

BY REX WHISTLER AND

AHA